Astrophotography

Astrophotography

A Step-by-Step Approach

Robert T. Little

Macmillan Publishing Company
New York

Collier Macmillan Publishers
London

Macmillan Publishing Company
866 Third Avenue, New York, NY 10022

Collier Macmillan Canada, Inc.

Printed in the United States of America

Printing Number
1 2 3 4 5 6 7 8 9 10

Library of Congress Cataloging in Publication Data

Little, Robert T.
 Astrophotography: a step-by-step approach.

 Bibliography: p.
 1. Astronomical photography. I. Title.
QB121.L57 1985 522'.622 85-10488
ISBN 0-02-948980-6

To the memory of
Thomas Allan Little

Contents

Foreword

by Isaac Asimov

I met Robert Little on the ship *Canberra* in 1973, when that ship was filled with a couple of thousand people heading for the African shore in order to view a total eclipse of the Sun. I cannot, in all honesty, say that meeting him was the highlight of the trip—the total eclipse I viewed on June 30 was. Bob, however, came next, for through him I was able to enjoy, vicariously, a life I could not possibly live for myself.

I don't travel, except with the greatest reluctance. It is not surprising, then, that the June 30, 1973 solar eclipse was the first I had ever seen—and the last, too. Bob Little, however, is an eclipse enthusiast. He routinely crisscrosses the world in search of those places and times when the sun is obscured. He has been to such places as Siberia, Mexico, Kenya, Indonesia, Australia, New Caledonia, and even Montana in his pursuit of the Moon's shadow.

Nor does he travel merely to experience the eclipse. Bob's mania is the photographing of it; catching on film, for permanent viewing, this most dramatic spectacle the Earth's sky affords.

And it isn't only eclipses that he photographs. There is not an aspect of the heavens that he doesn't point his telescope at and photograph. He produces marvelous spectacles on film, not with the far-out equipment of the professional astronomer but with telescopes and cameras that the amateur enthusiast can afford and use. He produces them not only on the mountain-top eyrie or the desert heights where the air is pure and the seeing best, but in the field, wherever he might be, and even in Brooklyn Heights where he happens to live.

I continued to be associated with Bob, because one trip he organizes year after year (inspired by the *Canberra* experience) is the "Astronomy Island" tour. During the week of July's new moon, he leads a group on a sea-cruise to Bermuda, which for four days and three nights is Astronomy Island to us. He has just completed the twelfth annual cruise of this type and it is so easy, comfortable, and fascinating that even I, travel-hater though I am, often join the group. I have been with them six or seven times, and have fully enjoyed myself on every such occasion.

On the lawn of a seashore estate, a variety of telescopes are set up, some brought there by members of the cruise and some by members of the Astronomical

Society of Bermuda. There follows the thrill of observing those planets that are visible, as well as double stars, globular clusters, planetary nebulae, the Andromeda galaxy—the sights never pall.

Nor are the days lost, for there is then the opportunity to observe the sun through appropriate filters.

And there are, of course, lectures during the day and a half it takes to reach Bermuda and the day and a half it takes to return; lectures rich in slides of astronomical phenomena and photographs of incidents during eclipse-hunting expeditions taken by Bob and those friends who help him guide us less fortunate ones through the world of astronomy. They even go so far as to allow me to give a lecture on some astronomy-related subject on the first evening of viewing on the estate.

Bob is fortunate in another respect, too. This overwhelming interest of his is not entirely avocational. It does not have to be stolen from some dull and prosaic way in which he is forced to make a living. His life is not a battleground between work and play, between necessary dullness on the one side and a devouring but expensive interest on the other.

Bob lives amateur astronomy all day every day because by profession he is involved in the marketing of telescopes. Everything he does, out of sheer fascination, helps him hone his expertise in the use and maintenance of telescopes and all their ancillary equipment—cameras, lenses, filters, drives, and so on. It is not surprising then that he is, in my opinion, the most knowledgeable person in the United States in matters concerning the techniques of amateur astrophotography—the science and art of photographing astronomical phenomena.

As it happens, I am a book-oriented person, not so much because I am an avid reader (though I am), but because I am an avid writer. To date, I have written, and published, more than 300 books. It hurts me, therefore, to see knowledge casually vanish that might be usefully given relative permanence in a book, just as it hurts Bob to see an astronomical vision casually vanish that might be usefully given relative permanence on film.

Experiencing Bob's expertise in the field, I was continually enthusiastic at any suggestion that he might write a book on the subject, giving all necessary down-to-earth instructions on how to turn out good astronomical photographs.

I was delighted when I finally saw the manuscript—clear, concise, and absolutely authoritative—and was even more delighted when Bob asked me if I might want to write a foreword. Of course I would. I am delighted to be associated with this book in which, as I read it, I can hear the authentic voice of Bob Little.

Acknowledgments

A grateful thank you to those folks whose continuous encouragement finally overcame my inertia and induced me to put this book together—namely, my wife Ethel; Janet and Isaac Asimov; and Allan Wittman.

and

A special thank you to the many people who helped me learn about astrophotography over the past twenty some years, including Robert S. Campbell, Richard Capps, Henry Courten, Raymond G. Coutchie, Mary Firth, Edwin Hirsch, George T. Keene, Alan McClure, Richard Nelson, Henry E. Paul, and Gerard Piel.

Introduction

This guide is for the beginning astrophotographer. It should be read through in one session in order to grasp the sense of the overall aspects. The reader should know how to use a camera for general photography, and as Chapter 2 reveals, much sky photography can be accomplished with simple equipment. For advanced astrophotography, the reader should know how to use an astronomical telescope. Except as noted, all photographs are by the author.

Sooner or later an estimated 90 percent of amateur astronomers try their hand at astrophotography. One reason is that a photograph is a tangible reward. Another is that many objects in the sky are too faint to be observed through telescopes of modest aperture, but can be stunningly photographed. Unlike the eye, film is capable of building up images over long periods of time. And, while the eye cannot perceive most colors at very low light levels, color film records such dim spectra. Many nebulae appear as a dim white glow to the eye, but are vividly colored on film. Further, events such as solar and lunar eclipses are transient, but photos last a lifetime.

Competition is one more reason for the popularity of amateur astrophotography. Most astronomy clubs have periodic contests for the best photos in various categories. The challenge to turn in the best seems to be a happy fixture of the human condition. Some amateur astrophotos even rival those of professional astronomers.

Amateur astronomers make real scientific contributions. Often new comets and supernovae are discovered by dedicated amateur astrophotographers.

Many aspects of sky photography are very easy, while others are more demanding. This guide begins with the easiest and continues on to the more complex.

The wise beginning astrophotographer will join a nearby amateur astronomy club because the collective experience of its members can provide friendly and enthusiastic assistance. The staff of a planetarium or an astronomy/earth science high school or college instructor should be able to put you in touch with a local group. Amateur astronomy clubs are found all over the world.

To keep abreast of amateur astrophotography advances, reading the two leading monthly journals of popular astronomy is a must. Many libraries subscribe to *Sky & Telescope* and *Astronomy* magazines. Subscription information may be obtained by writing to:

Sky & Telescope
Sky Publishing Corporation
49 Bay State Road
Cambridge, MA 02238-1290

Astronomy
AstroMedia Corporation
625 East St. Paul Avenue
P.O. Box 92788
Milwaukee, WI 53202

Suggested further reading

Astrophotography Basics, Kodak customer service pamphlet AC-48, Eastman Kodak Co., Consumer/Professional & Finishing Markets, Rochester, NY 14650

Astrophotography, by Barry Gordon (published privately), 845 West End Avenue, New York, NY 10025

The Hidden Sun, by James Lowenthal. Avon Books, 1790 Broadway, New York, NY 10019

Editorial notice

In any printing process details in the original slides will be lost. This is especially true when reproducing astronomical photographs. Because of these limitations, some color slides have been reproduced as black-and-white prints.

Astrophotography

Equipment Needed

CAMERAS

Almost any camera is capable of *some* celestial work, but because the 35 mm single lens reflex (SLR) with focal plane shutter and interchangeable lenses is the most versatile system it will receive most of our attention in these pages. Larger format SLRs can be successfully used, but the range of films is greatest for 35mm cameras. Also, fittings to connect 35mm cameras to telescopes are more easily obtainable.

It is imperative that the camera be capable of manual operation. Some are automatic to the degree that one cannot choose shutter speeds and lens aperture settings independent of one another. These are not suitable for most astrophoto applications. Fortunately, most popular brands offer a manual mode.

FILMS

Black-and-white films, except for photographs of the moon and certain other applications, are passé. Today's fast color films quickly capture splendid views that would have been impossible for the amateur only a few years ago.

Because film technology changes rapidly, it is impossible to recommend a specific film for each application. And, no one film is ideal for all applications. However, the beginner should start with commonly available fast (ISO 200 to 1000) color slide *daylight* films. These slide films do not require special developing techniques (see further comments about handling), and prints can often be made more successfully from slide film than from negative (print) film because the film laboratory technician can see the colors and detail of these unfamiliar subjects more clearly than on a negative. However, color negative film generally does render better color latitude, and, properly handled, will deliver somewhat better results. Film speed is rated in ISO (formerly ASA) numbers—the higher the number, the faster the film. Each photographic chapter includes a recommended film speed for the purpose at hand. Newer and faster films (as of this writing ISO 2000 is in

the wind) should be tried. Chapter 2 discusses Polaroid's Polagraph® auto process film, which is useful in teaching situations and in determining correct exposures for other films.

FILM PROCESSING

Because astronomical photography is unfamiliar to most film processing technicians, it is possible that a slide might be cut down the middle. After a roll of film is developed by a fully automated process, a technician places it in a machine that cuts and mounts the individual slides in frames. The first photo is aligned in the machine by the technician, and a simple push of a button starts the cutting and mounting process while the operator watches to see that each frame is cut at the point of separation from the next. But astrophotos rarely show clear frame-to-frame borders. This can result in a series of half-photos, as shown in Figure 1.1.

The *only* completely safe way to avoid the half-photo syndrome is to make the first photo one of a normal terrestrial scene that will clearly show its borders, and to include a note to the processor stating, "DEVELOP ONLY—Do not cut and mount slides (Figure 1.2)." The developed film strip will be returned whole. It is a simple matter to cut the film with a pair of scissors and mount the individual slides in holders available in most photo shops. The normal photo will serve as a guide to start the hand cutting operation. Play it safe!

If one is lazy and willing to take a slight chance with the half-photo problem (the author does it often), make the first exposure a "normal" daylight one. For every third frame, shine a flashlight into the photographic lens and open the shutter for ¼ second. The flashlight shots will fill the frames and show clear separations. The chances are that the photos will not be cut in half. Include a note to the processor, "Mount *all* slides—even those that appear blank or useless." Non-astronomers will interpret many celestial photos as blanks.

As experience is gained, the astrophotographer may wish to experiment with special films or with custom developing techniques. Amateurs regularly report on both in the monthly pages of *Sky & Telescope* and *Astronomy* magazines. Both are very informative.

TRIPODS

For some forms of astrophotography all that is required is a camera and tripod (Figure 1.3). When using a lightweight camera/lens combination, almost any tripod will suffice. Heavier lenses need greater stability. Determine your tripod requirements by your intended uses. Before investing in a tripod, try to rent or borrow a couple for testing. Keep in mind that while a tripod can be too shaky, it can never be too steady.

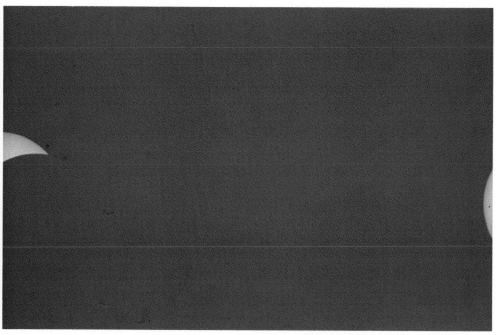

1.1–*The only completely safe way to avoid the half-photo syndrome is to have the developed slide film returned uncut and do the mounting yourself. This illustration shows two half photos of a partially eclipsed sun.*

1.2–*Affix a sticker to the film cassette clearly stating that the strip is to be returned uncut. Be sure to have the same instructions written on the envelope in which the film is sent to the processor.*

DEVELOP ONLY
Do not cut
and mount slides

1.3—A combination of camera and tripod offers a surprising amount of very rewarding sky shooting. A tripod can be too flimsy, but never too steady.

TELESCOPES

For advanced astrophotography, a telescope is required. Just about any *astronomical* telescope can be successfully used. It should, however, be equipped with a right ascension (clock) drive. At the very least, it should have an easy-to-use hand drive. The instrument may be a refractor, reflector, catadioptric, or any combination of these (Figure 1.4). Not all will do everything, but any one type is capable of a great deal.

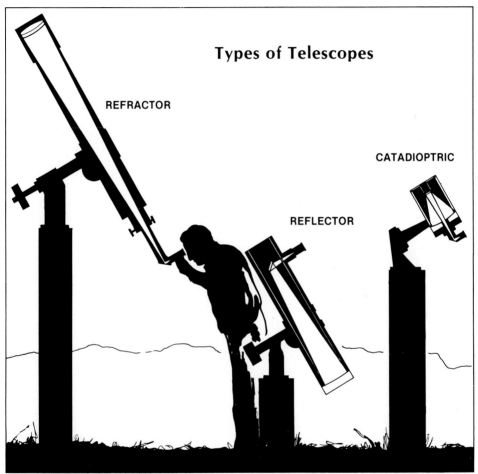

1.4–These three telescopes all have an 8-inch aperture (and hence equal light-gathering ability), despite their differences in size and weight. If an observer wants each eyepiece to be at standing-eye-level, as shown here, the mountings must be of quite different heights, which also affects cost and portability. The tubes are cut away to show the light paths. Diagram courtesy Sky & Telescope astronomy magazine. © 1983, Sky Publishing Corporation.

1.5–For cameras that do not have interchangeable prism/right-angle finders, an accessory finder is available at modest cost. When connected to the viewing window, it can help avoid a crick in the neck while photographing celestial objects.

Focusing
eyepiece

Swivel
joint

ACCESSORIES

Some forms of celestial photography require accessory items. These include drive correctors, guiding eyepieces, guiding systems, Barlow lenses, eyepiece projection fittings, focal reducers, and so on (Figure 1.5). They will be described as they apply.

Astrophotography with Camera and Tripod

Any camera that has a provision for locking its shutter open for as long as desired is capable of beautiful sky photography. These include the recommended SLRs as well as rangefinders and cameras with even simpler viewfinders. A locking cable release is necessary to hold the shutter open with most cameras. As many astrophotos exceed a fraction of a second, a tripod is a practical need.

STAR FIELDS (CONSTELLATIONS)

Star-field photography is easy and rewarding. High-speed film (ISO 400) and a reasonably fast (f/2.8) 50mm lens will record such areas as the Big Dipper in as short a time as 6 seconds. Longer exposures will record more (fainter) stars. If the lens is slower by one stop (f/4), twice the exposure time is required. If the lens is faster by one stop (f/2), only half the exposure time is needed and at f/1.8, only 2 seconds are required. If ISO 200 film is used, double the exposure time, and if ISO 1000 film is in the camera, use about half the time. ISO 400 Polaroid Polagraph® is an excellent film for beginners (Figure 2.1). This film is discussed in detail later in this chapter.

Because the earth rotates, stars will trail in photos taken with a stationary camera (Figure 2.2). However, a star-field photo of objects close to the celestial equator taken with a 50mm lens will not show any appreciable movement in exposures up to 30 seconds, and exposures up to 45 seconds can be used for objects farther north or south of the celestial equator. A 100mm lens will usually

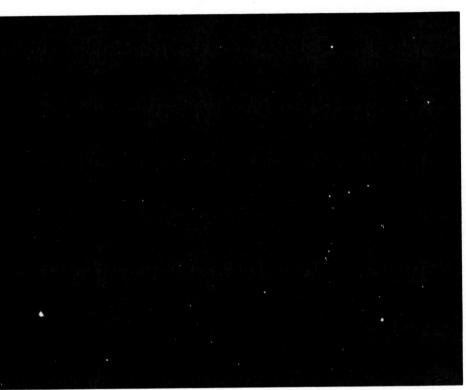

2.1 Orion. 10 seconds, 50mm f/1.8 lens, ISO 400 Polaroid Polagraph® "instant" slide film. This black-and-white film is ideal for many teaching situations because the results can be seen on the spot. Of course, the lack of color is a sacrifice. Photographed in New York City.

This film and all Polaroid 35mm slide films are very delicate and scratch easily. Some "stars" in this New York City photo are small defects. See illustrations 2.11 through 2.17 and 2.27 through 2.29 for other examples of these new films.

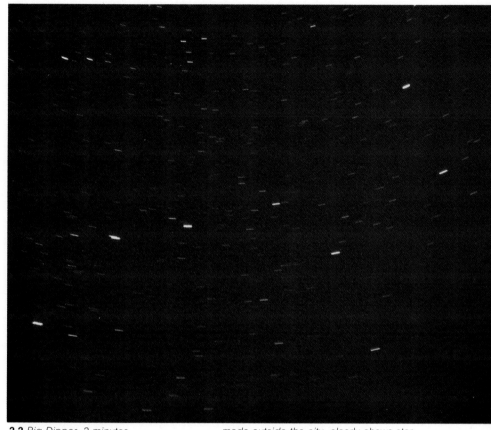

2.2 *Big Dipper. 3 minutes,*
50mm f/2.8 lens, ISO 400
Ektachrome film. This photograph,
made outside the city, clearly shows star
trailing and records many more stars in
different colors.

show trailing after only 15 seconds. Sometimes it is desirable to record star trails against the sky's background to emphasize a constellation. Take several shots of a given star-field at different exposures for varying effects (Figure 2.3).

Best photos of stars are obtained on moonless nights away from city lights and smog (Figure 2.4). The longer the exposure and the faster the film and lens

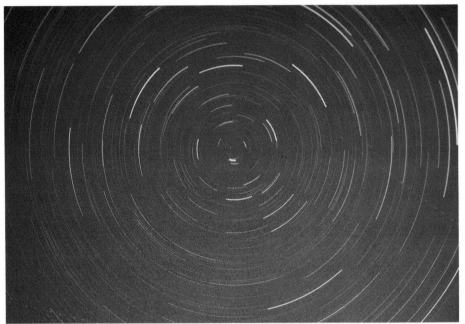

2.3 *North Star and circumpolar trails. 3 hours, 50mm f/2.8 lens, ISO 160 Ektachrome film. A vivid photo that shows the effects of the Earth's rotation (note airplane trails). As can be seen, Polaris is about a degree off true north. Different films will record slightly different colors, and the background color of the sky is* *further altered by the type and intensity of light and air pollution. The altitude at which photos are taken can also affect color. This is an easy way to test the characteristics of film behavior during very long exposures required for some forms of deep-sky work as described in Chapters 4 through 7.*

2.4 *Big Dipper section of Ursa Major. 45 seconds, 50mm f/2.8 lens, ISO 160 Ektachrome film. Star trailing is almost invisible in this photo shot away from city lights under a moonless sky. Black-and-white print made from slide.*

aperture, the more critical clear dark skies become. Light pollution can cause film to fog and result in a brightening of the background and loss of contrast. Even so, successful star-field photography can be accomplished in metropolitan areas. With imaginative composition, impressive results can be realized (Figures 2.5 and 2.6).

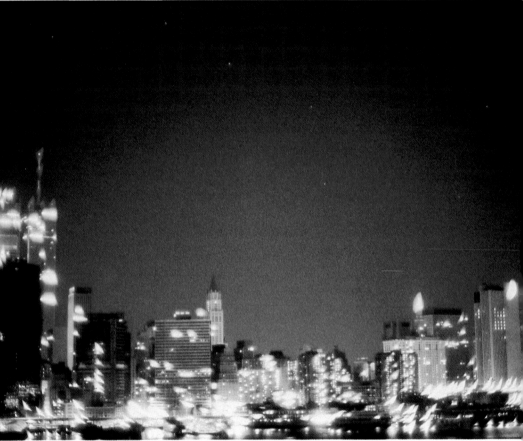

2.5 *Big Dipper over New York City. 2 seconds, 50mm f/1.8 lens, ISO 400 Ektachrome film. Constellations can be photographed in metropolitan areas, sometimes with dramatic effect.*

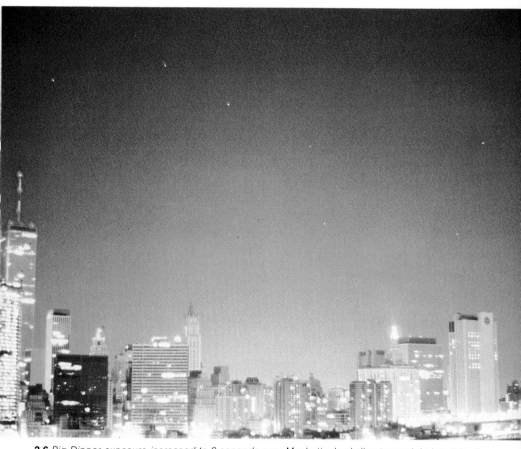

2.6 Big Dipper exposure increased to 6 seconds over Manhattan's skyline turns night into "day."

The area of sky that can be photographed on 35mm film is determined by the focal length of the lens. A 50mm lens covers some 28 by 41 degrees. The Big Dipper portion of the constellation Ursa Major is about 25 degrees in its longest dimension and can easily be framed. By measuring the section of sky to be photographed using a star chart, the proper focal length lens to cover a given section can be selected from the following:

Angular Field Coverage Of 35mm Lenses (approximate)

Focal Length (mm)	24mm Dimension (in degrees)	36mm Dimension (in degrees)
20	69	103
28	49	74
35	39	59
50	28	41
85	16	24
105	13	20
135	10	15
150	9.2	13.8
200	6.9	10.3
250	5.6	8.3
300	4.6	6.9
400	3.4	5.3
500	2.8	4.1

NOTE: The increasingly popular zoom lenses can encompass a range of sky coverage and the above scale applies. Careful attention to the f/ratio is needed to determine exposure time. As focal length increases, the speed decreases. (Some zoom lenses slip their settings when aimed upward. The mechanism can be secured with tape to prevent slippage.)

To photograph a star field, proceed as follows:

1. Load camera with proper film.
2. Take normal photo in daylight.
3. Select a lens that will encompass the field.
4. Mount camera on tripod.
5. Set lens at fastest opening and focus at infinity. (NOTE: Some lenses will not deliver sharp star images at the edges of the photo due to coma. Closing the aperture down one or two stops should correct this. Exposure time should be doubled for each decrease in aperture).
6. Attach cable release.
7. Set camera shutter speed to B (bulb).
8. Frame star field in camera viewfinder and lock tripod. (NOTE: Make sure lens is free from condensation. If dew has formed, wipe clear with soft lint-free cloth. A lens shade will retard dew formation and help eliminate stray light.)

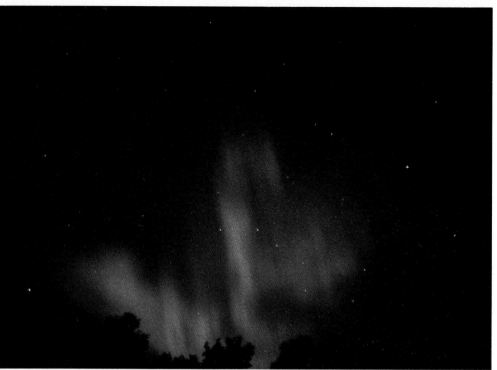

2.7 *Northern Lights. 23 seconds, 20mm f/2.8 lens, Ektachrome 400 film. Exposure times vary according to brightness of aurora and coloring varies greatly from* *event to event. Compare size of Big Dipper to Figure 2.4 which was shot with a 50mm lens. Illustration used with permission of Dr. Andrew Steinbrecher.*

9. Begin exposure by gently depressing and locking cable release.
10. Time exposure.
11. Unlock cable release to end exposure.
12. Record all pertinent data for future use. Include sky condition, lens focal length and aperture, film brand and speed, area photographed, date, time. All data will be of use for future duplication and/or correction.

NORTHERN AND SOUTHERN LIGHTS

Northern Lights (aurora borealis) and Southern Lights (aurora australis) photography is similar to star-field photography except that exposure times are less certain. The brightness, colors, and structure of these phenomena vary greatly and exposure times must be guessed (Figure 2.7). A series from 10 to 90 seconds with a 50mm or wide-angle lens set to the fastest aperture, and 400 or faster speed film should capture the spectacle. Placing a terrestrial foreground in the picture can add an interesting touch. Because these events are largely unpredictable, it's a lucky person who is ready to photograph an aurora when it occurs.

COMETS

Comet photography presents its own unique problems. If a comet is very dim (below the threshold of naked-eye vision), "tracking" photography is required (see Chapter 4). A comet visible to the naked eye is photographed in exactly the

2.8 *Comet Bennett. 30 seconds, 35mm f/2.8 lens, ISO 160 Ektachrome film. A comet visible to the naked eye and easily* *photographed with simple equipment. Star trailing is virtually nonexistent because of short focal length and exposure.*

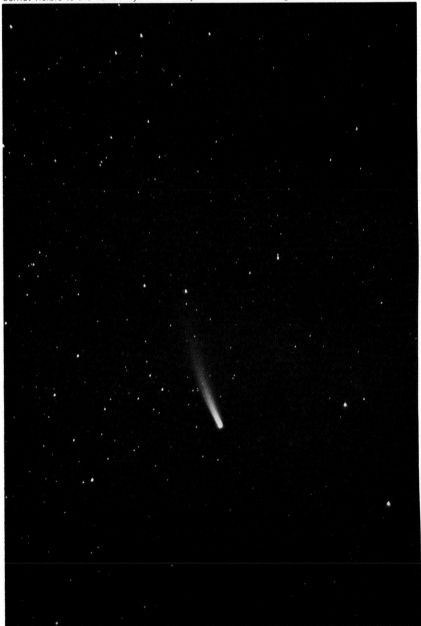

same manner as star-fields (Figure 2.8). Determine the optimum focal length lens to be used by the length of the comet's tail, in degrees, from published data. A series of exposures ranging from 10 to 90 seconds should produce nice photos with a 50mm focal length lens. A longer focal length will enhance star trails.

2.9 *Comet West. 10 seconds, 135mm f/1.8 lens, ISO 400 Ektachrome film. Some comets can be captured on film in cities.* *The results may not be as beautiful as photos taken in the country, but city dwellers don't always have a choice.*

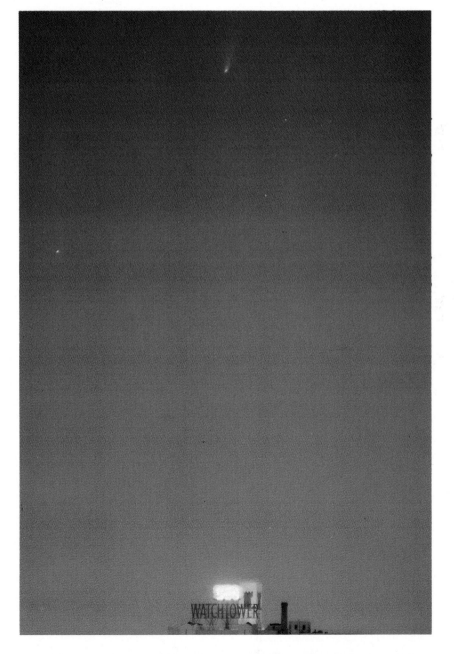

METEORS

Although they appear in the sky every night, on certain dates each year, meteors occur as showers (Figure 2.10). Because they are generally quite bright, they can sometimes be photographed when the moon is in the sky. However, the darker the sky, the more dramatic the pictures. Most meteors are seen after midnight. Photography of meteors is similar to that of star fields. Aim the camera toward the section of the sky that the astronomical reports suggest and lock the shutter open. The longer the exposure, the more likely a meteor or two will be recorded. However a very fast film and a lens opening of f/2.8 could photograph more sky fog than meteors. Try a lens opening of f/4 and a film speed of 200 for half-hour periods under dark skies. Remember, the longer the exposure time, the longer the star trails.

2.10 *Meteor shower. 3.5 minutes, 105mm f/3.5 lens, ISO 400 Tri-X black-and-white film. About 70 trails were recorded on the negative during the spectacular Leonid meteor shower of 1966. A color photo would, of course, be even more beautiful. Illustration used with permission of* Sky & Telescope's *photo whiz, Dennis Milon.*

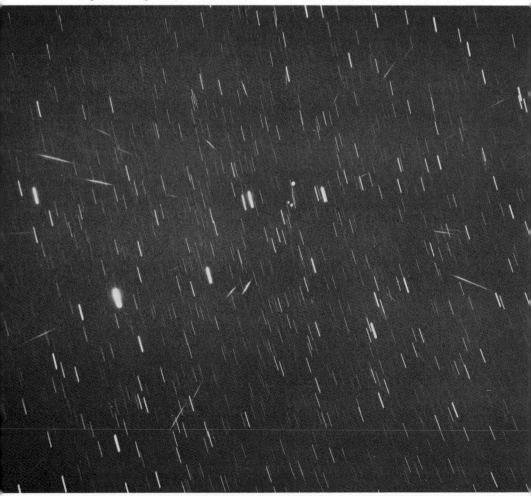

2.11 Moon. 1/250 second, 1200mm f/12 mirror lens, Polagraph film. Actual size reproduced here. Note that exposure time was the same as that for f/16 lenses. Many mirror lenses are "slower" than their rated speed.

2.12 Moon at last quarter. 1/30 second, 1200mm f/12 mirror lens, ISO 400 Polagraph film. Actual size reproduced here. Note greatly increased exposure time over full moon.

THE MOON

Because our satellite is so bright, moon photography, falls into the category of snapshots. A full moon, high in the sky, requires an exposure of only about 1/250 second on ISO 400 speed film with a lens set to f/16 (Figure 2.11). A quarter moon needs about 1/15 or 1/30 second with the same film speed and lens aperture (Figure 2.12). A four-day crescent moon required about ⅛ or ¼ second.

Although the moon appears to be a large object visually, it is only one-half degree in diameter. Using a 50mm lens, its image on film measures a tiny 0.5 mm (Figures 2.13 and 2.14). Even this small image will show some surface detail, but longer lenses will produce much more. Because 35mm film measures some 24mm in its narrow dimension, it follows that a focal length of 2400mm is about the maximum that can be used to capture the entire disk. Each 100mm of focal length produces a lunar image of about 1mm on film. Focal lengths of 300mm and longer can yield very vivid photographs.

Exposure times will vary greatly according to the moon's altitude above the horizon and the amount of pollution in the air. The lower the moon and the denser the pollution, the longer the exposure. Take a couple of shots at what seems to be the correct exposure, and then take a couple more at half the time (1/500) on ISO 400 film at f/16 for the full moon and one or two more at twice the exposure time (1/125).

Although color film can produce pleasing hues, the moon is really a *black-and-white* object. If the moon appears colored to the eye it is the result of pollutants in the atmosphere. This can render beautiful photographs, but black-and-white film will yield the most accurate photos of the moon's true appearance (Figures 2.11 through 2.17).

Polaroid Corporation offers Polagraph ® auto process ISO 400 black-and-white slide film of very high contrast, which was used for all the moon shots in this chapter. Because the self-processing time is only about five minutes from

2.13 Moon. 1/250 second, 50mm f/16 lens, ISO 400 Polagraph film. Actual size reproduced here. 50mm renders an image about 0.5mm in diameter.

2.14 Moon enlarged 20 times from 50mm photo shows some detail. "Stars" are slight defects in film. Polagraph scratches easily.

2.15 *Moon. 1/250 second, 135mm f/16 lens, ISO 400 Polagraph film. Actual size reproduced here.*

2.16 *Moon. 1/250 second, 300mm f/16 lens, ISO 400 Polagraph film. Actual size reproduced here.*

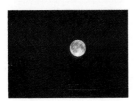

2.17 *Moon. 1/1000 second, 500mm f/8 lens, ISO 400 Polagraph film. Actual size reproduced here. Note fuzzy image. Lens was of mirror type and was past infinity at that setting. Make certain lenses behave according to their scales.*

the last exposure to projection-ready slides, one can photograph the moon, view the results, and make exposure corrections on another roll of film the same night. This moderately grainy film is also useful to determine exposure times for films with different speeds. For instance, if a much slower (ISO 32), finer-grained film is to be used, the "instant" Polagraph exposures can help determine the needed exposure times for the slower film. For example, a correct exposure of 1/250 with the ISO 400 film would indicate that ISO 32 film (about four stops slower) would need an exposure of 1/30 or 1/15 second. The advantage of this comparative method is that it virtually assures correct exposures. If the slow film had been used without reference to the Polaroid film, the results would not be known until the film was processed in a laboratory. Another month would go by before the same phase of the moon could again be photographed.

LUNAR ECLIPSES

Although lunar eclipses occur on a predictable schedule, it is impossible to pre-determine exposure times, because the brightness of the eclipsed moon varies greatly from one eclipse to the next. Sometimes the moon appears bright red, and other times it can hardly be seen. A fast color film (ISO 1000) with a lens set to its fastest aperture, and a series of photos taken at different shutter speeds all the way to a few seconds long, should record at least one satisfactory image.

THE SUN

Photographing the sun can be *very dangerous*. Improperly done, solar photography can cause instant *permanent* blindness. At the very least damage to camera and telescope lenses and camera shutter mechanisms can be caused by the sun's intense heat. *Never* look at the sun with the naked eye or through a telescope or camera's viewfinder unless a *specially designed* filter for solar use is employed. The beginner (including experienced photographers with no solar photography experience) should seek expert assistance before attempting a photo of the sun.

Properly done, stunning photos can be taken that will reveal everchanging sunspot activity. Because the angular diameter of the sun is the same as that of the moon (one-half degree), a long focal length lens will capture more detail than a short one. The extreme brightness of the sun is further increased through lenses and requires a metallic-coated filter of neutral density (ND) 5 which reduces the light about 100,000 times.

WARNING: An ND 5 filter is not the same as a 5× filter. The latter is totally unsafe! Furthermore, not all ND filters eliminate the dangerous infrared rays. Only specially made filters with metallic coatings provide safety. These can be purchased from a variety of sources advertised in the popular astronomical journals. Some of these special filters cause the sun to appear orange, others blue or white, but all are placed in *front* of the telescope or lens to keep intense heat and light out of the system. *Never* use sun filters that fit into the eyepieces of telescopes, because they crack from heat and can cause permanent blindness. These sun filters are commonly supplied with telescopes made in the Orient.

After placing the appropriate filter over the aperture of the lens and making certain it is firmly attached, proceed in the same manner as for lunar photography. Using ISO 400 film and a lens opening of f/16, an exposure of 1/250 should be about right. However it is wise to bracket exposures (faster and slower), as is done in lunar photography.

SOLAR ECLIPSES

Solar eclipses are predictable. Some are partial (the moon does not fully cover the solar disc) and some are total. Photographing a partial solar eclipse is the same as noneclipse photography. *All the same precautions must be taken!* Exposure times are the same.

WARNING: Just before and just after the moon completely covers the sun, a small amount of sunlight creates an image known as the Diamond Ring which lasts for a second or two. This aspect of the eclipse is photographed *without* a filter. *Extreme caution must be taken to protect the eye.* The only safe way to photograph the Diamond Ring is to mount the camera on a tripod and, without looking into the viewfinder, remove the filter and take the photo when the Diamond Ring occurs (1/500 second with ISO 400 at f/16).

Total solar eclipses are spectacular visually and photographically. The partial phases are shot exactly as above. When the moon completely covers the sun (during totality), remove the filter and take a series of photos at each available shutter speed. This will produce a beautiful sequence showing crimson solar flares and Bailey's Beads (fast exposures) on through shots of the inner, mid, and outer coronas. As soon as the first burst of sunlight reappears, creating the Diamond Ring, photograph it, following the precautions listed above, then replace the filter (for further photography) or aim the camera away from the sun. Figures 2.18 to 2.24 show this exciting sequence.

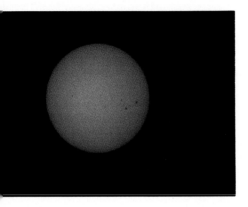

2.18 Solar eclipse sequence, 1981. 1/250 second, 1200mm f/12 mirror lens with ND5 metallic filter, ISO 400 Ektachrome film.

2.19 First "bite". 1/250 second with filter.

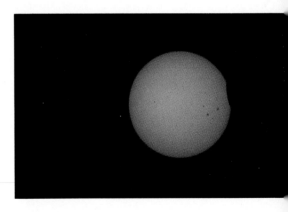

2.20 About halfway to totality. 1/250 second with filter.

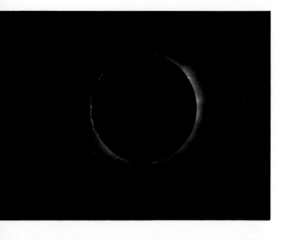

2.21 *Totality. 1/250 second with filter removed (see text for safety procedure). Note beautiful prominences.*

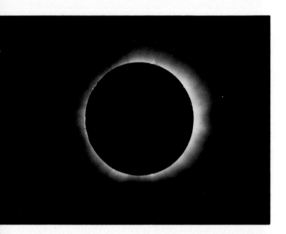

2.22 *1/125 second, no filter. Prominences fade as corona begins to record.*

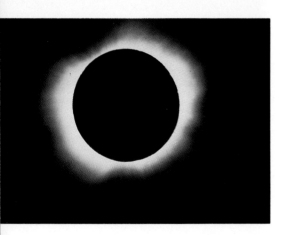

2.23. *1/30 second, no filter. Prominences about invisible as corona obliterates them.*

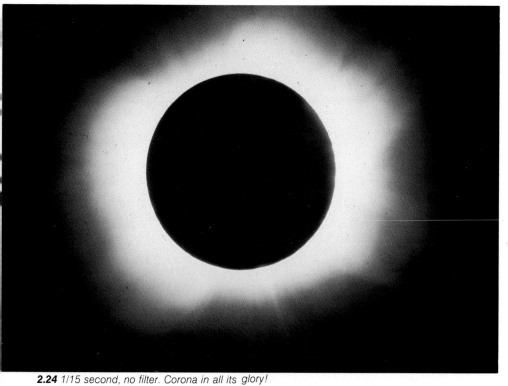

2.24 *1/15 second, no filter. Corona in all its glory!*

Because the sun is so bright, it is possible to photograph it without a tripod. A very fast film (ISO 1000) will be a decided asset in this case. Any focal length lens will produce "nice" pictures, but in order to capture fine detail, a 300mm or longer lens is needed. However, too long a focal length will record an image of the eclipsed sun without room for the corona. As with lunar photography, 2400mm is about the maximum that can be used to fit the entire disc onto the 35mm frame. A range of 400 to 1200mm is generally good. Of course, the longer the focal length, the steadier the photographer must be! Figures 2.18 through 2.26 were shot with a tripod.

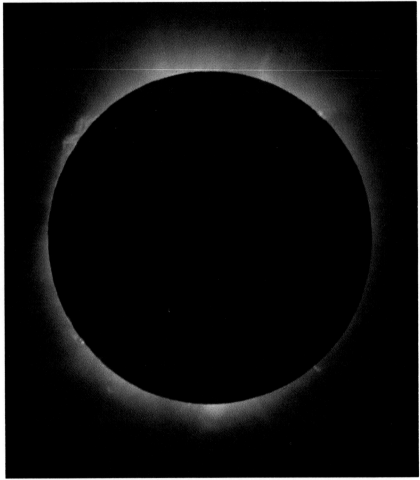

2.25 *Solar eclipse 1979. 1/125 second, 1500mm f/10 mirror lens, ISO 400 Ektachrome film. This was shot through thin cirrus cloud cover which did not prevent the capture of beautiful prominences, although clouds did cause outer corona to register somewhat fuzzy.*

2.26 Life *magazine published a major article on the 1979 solar eclipse and chose Figure 2.25 for its cover. Courtesy* Life *Picture Service,* Life *Magazine © 1979 Time Inc. Photo by Robert T. Little and George T. Keene.*

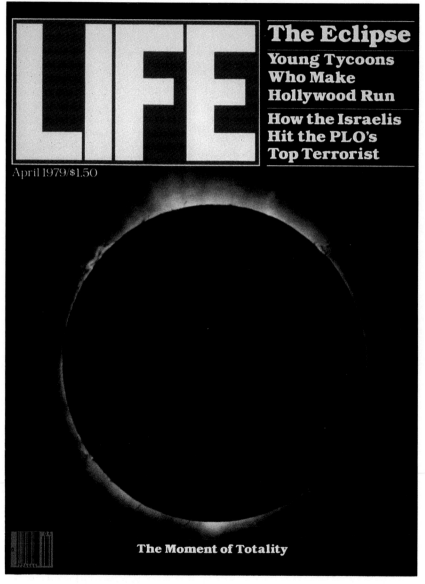

LIFE

The Eclipse

Young Tycoons Who Make Hollywood Run

How the Israelis Hit the PLO's Top Terrorist

April 1979/$1.50

The Moment of Totality

2.27 Solar eclipse, 1983. 1/60 second, no filter (see text for safety procedure), 1200mm f/12 mirror lens, ISO 40 Polaroid Polachrome film. Small "Diamond Ring." Motor-driven telescope. Polachrome scratches easily. Handle with care.

2.28 "Baileys Beads." 1/60 second, no filter.

Another "instant" slide film available from Polaroid Corporation is Polachrome® color reversal (slide) ISO 40. This film is too slow for most astrophoto purposes, but the author was able to use it to meet a critical press deadline for a story about the Indonesian solar eclipse on June 11, 1983. The film's slow speed required that a telescope with motor drive be used; the results were fine. The instant photos (Figures 2.27, 2.28, and 2.29) were flown via the first available jet out of Indonesia. Although the quality of this film at present does not equal conventional films, its almost inevitable improvement will be a real boon for astrophotographers.

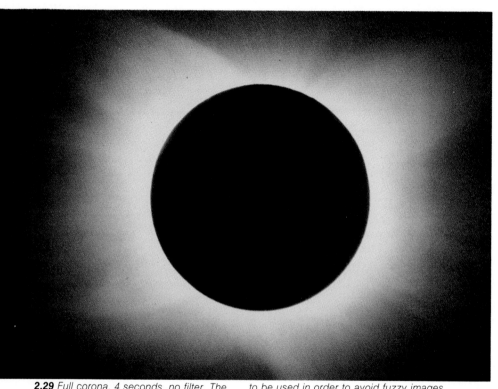

2.29 *Full corona. 4 seconds, no filter. The slow ISO 40 required the telescope motor to be used in order to avoid fuzzy images with slow shutter speeds.*

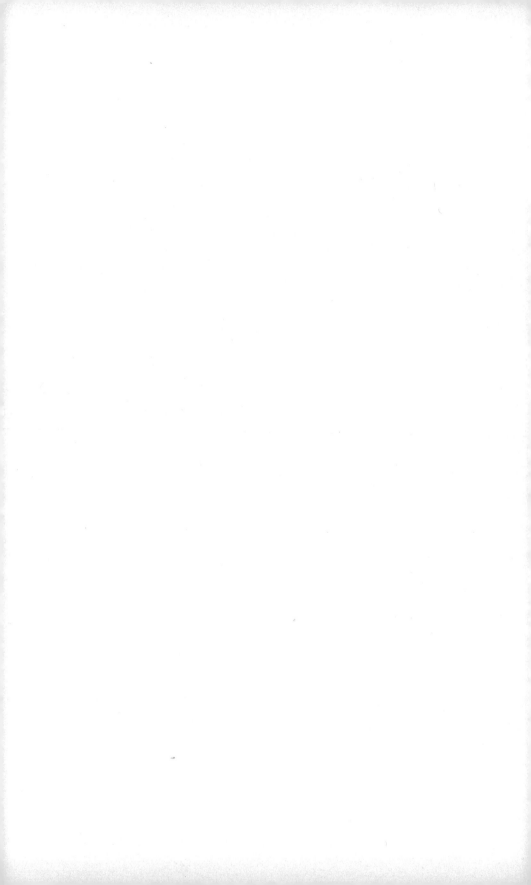

Astrophotography with a Telescope

Except for snapshot photos of the sun and moon, all forms of sky photography that employ a telescope require a drive mechanism in right ascension and accurate polar alignment.

RIGHT ASCENSION DRIVES

Right ascension drives, whether electrical, weight driven, or hand controlled, serve to offset the effects of the earth's rotation. If telescopes could not follow the stars, long duration and very high-power photography could not be accomplished. Sharp images would be impossible.

POLAR AXIS ALIGNMENT

Polar alignment need not be very accurate for casual observing. If the viewed object drifts from the center of the field, periodic adjustments in right ascension and declination correct the problem. This luxury is virtually nonexistent in advanced astrophotography. Although adjustments are required, they are very limited. To accurately polar align a telescope, proceed as follows:

Align your telescope's polar axis in accordance with the instructions supplied with it. These methods vary according to the manufacturer, and though they are

all accurate enough for *viewing*, they are not nearly accurate enough for good astrophotography.

After rough alignment on the celestial pole, insert a crosshair reticle eyepiece into the instrument and point it at a bright star as near as possible to the intersection of your meridian and the celestial equator. The nearer to this point a star can be found, the greater the ease of attaining proper alignment. Now, with the clock drive in operation, watch the drift of this star in declination while ignoring any drift in right ascension:

If the star drifts *south,*

the polar axis points *east* of the pole.

If the star drifts *north,*

the polar axis points *west of the of the pole.*

Shift the telescope's polar axis by small amounts in the correct direction until all declination drift ceases over a period of five minutes or so. The higher the power of the eyepiece, and the longer the telescope does not drift in declination, the greater the accuracy of this phase of alignment. In fact, the next step is generally not necessary if all photography is done while the object is very near the meridian. But if greater accuracy is desired, continue on.

Point the scope to a bright star about 20 degrees or so above the eastern horizon and close to the celestial equator. Once again, monitor the drift in declination only:

If the star drifts *south,*

the polar axis points *below* the pole.

If the star drifts *north,*

the polar axis points *above* the pole.

Adjust the telescope's polar axis again by small amounts until all declination drift ceases as described above. When this is done, a highly accurate polar alignment will be achieved.

NOTE: The corrections above pertain to the Northern Hemisphere. Corrections should be reversed for the Southern Hemisphere.

Deep-Sky Piggyback Photography

As we have seen, star-field photography is very simple. But in order to capture very faint stars, nebulae, galaxies, faint comets, and the Milky Way without trailing, the camera must follow the stars (Figure 4.1).

4.1 *Andromeda. 60 minutes, 50mm f/2.8 lens, ISO 100 Anscochrome film. This was taken in the early 1960s with the "breakthrough" of a fast color emulsion. Because the exposure time required was so long, the telescope had to be guided (see Chapter 5). This was the author's first attempt at "piggyback" photography and because he did not know how to polar align a telescope properly, field rotation of the stars resulted. Nonetheless, the Andromeda Galaxy did record. He then set about devising a method to polar align telescopes quickly and accurately (see Chapter 3).*

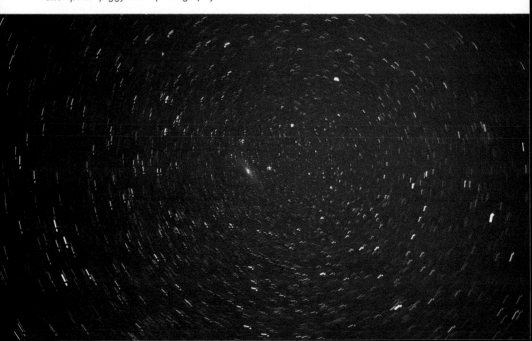

PIGGYBACK MOUNTS

Most telescope manufacturers offer an accessory for mounting a camera in a fashion that permits it to photograph the sky utilizing the telescope's drive to offset the earth's rotation. These are commonly called *piggyback* mounts (Figures 4.2 and 4.3), and in combination with the telescope's drive, they will keep the camera on target for as long as desired. To appreciate the advantages, compare the photos taken with piggyback mounts to those made with stationary cameras, shown first in each series.

4.2 *Typical piggyback mounts for reflectors and refractors.*

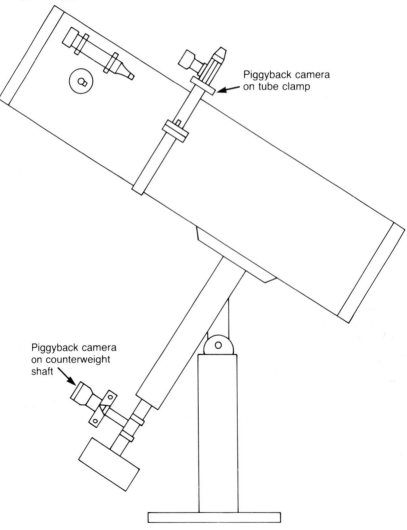

Piggyback camera on tube clamp

Piggyback camera on counterweight shaft

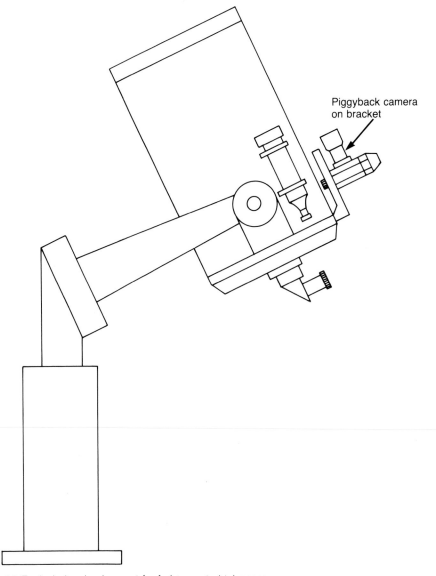

Piggyback camera
on bracket

4.3 *Typical piggyback mount for fork mounted telescope.*

Exposure times must be determined experimentally because film speeds and emulsions change rapidly. Today's fast films and lenses can photograph the Andromeda Galaxy (Figures 4.4 and 4.5) or the Northern Cross (Figures 4.6 and 4.7) in only 2 minutes! Try ISO 1000 film and a lens aperture of f/2.8. The Rosette Nebula, which is all but impossible to see in most amateur telescopes, can be

4.4 *Andromeda. 5 seconds, 50mm f/2.8 lens, ISO 1000 3M slide film. Camera* *stationary on tripod. Black-and-white print made from slide.*

4.5 *Andromeda. 2 minutes, 135 mm f/1.8 lens, ISO 1000 3M slide film. Compare this piggyback photo to Figure 4.4, which was* *taken with a 50mm lens stationary on a tripod. Also see Figures 4.8 and 4.9 for comments about star images.*

4.6 *Northern Cross. 5 seconds, 50mm f/2.8 lens, ISO 1000 3M slide film. Camera* *stationary on tripod. Black-and-white print made from slide.*

4.7 *Northern Cross. 2 minutes, 135mm f/2.8 lens, ISO 1000 3M slide film. Compare this piggyback photo to Figure 4.6, which was taken with a 50mm lens* *stationary on a tripod. Figures 4.4 through 4.7 were taken near New York City. Light pollution degraded contrast.*

recorded in 3 minutes on ISO 400 film at f/1.8. Whatever the object, start exposure times from published photo data and take a series one stop faster and one stop slower than what seems to be the optimum, as was done in Figures 4.8 and 4.9 in photographing Orion; Figures 4.10 and 4.11 are other photos of Orion.

4.8 and 4.9 *Orion. Compare these 135mm, ISO 400 Ektachrome film photos. The first is a 3-minute exposure with the lens set at f/1.8 and shows very unsatisfactory star images. The second is a 6-minute exposure with the lens at f/2.8, about a stop slower; it shows much better images. Most camera lenses do not produce sharp stellar images at their wide open settings. A stop or two down usually does the trick. Double the exposure time for each decrease in lens aperture.*

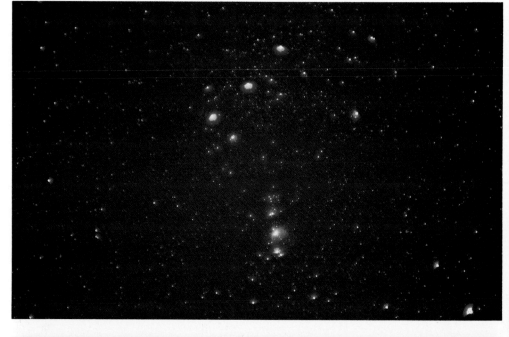

4.10 *Orion. 45 seconds, 50mm f/2.8 lens, ISO 160 Ektachrome film. This was taken in New York City. Note that the nebula began to record and that star trailing is apparent. In Chapter 2, Figure 2.4 a* *45-second exposure of the Big Dipper shows no discernible trailing. Orion does because it is nearer to the celestial equator.*

4.11 *Orion. 3 minutes, 50mm f/1.8 lens, ISO 400 Ektachrome. Compare this photo which was taken piggyback to Figure 4.10.* *This was taken away from city lights and pollution. Note Rosette Nebula in upper left area.*

As pointed out in Chapter 2, the longer the focal length of the lens, the narrower the view, but you get a larger image scale of objects within the field (Figures 4.8, 4.9, 4.10 and 4.11).

Before starting a deep-sky photograph, it is a good idea to have a loose-fitting lens cap handy to block the light from airplanes, approaching automobiles, and the like. It is also useful when gusts of wind vibrate the apparatus. Wind is an enemy!

4.12 *Sagittarius. 5 minutes, 135mm f/2.8 lens, ISO 1000 3M slide film.*

4.13 *Teapot in Sagittarius. 5 seconds, 50mm f/1.8 lens, ISO 400 Ektachrome film.* Camera stationary on tripod. Black-and-white print made from slide.

4.14 *Teapot in Sagittarius. 3 minutes, 50mm f/1.8 lens, ISO 400 Ektachrome film. Compare this piggyback photo to Figure 4.13. This reproduction is a second-generation* duplicate which has lost much detail. Original lost. See Figures 7.8 and 7.9 for some good news about duplication.

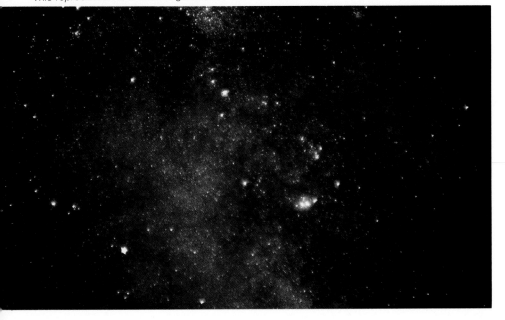

To take piggyback photos, proceed as follows:

1. Load camera with ISO 400 or 1000 speed film.
2. Take normal photo in daylight.
3. Select a lens that will encompass the field.
4. Accurately polar align telescope.
5. Attach piggyback mount to telescope.
6. Attach camera to piggyback mount and aim the camera in roughly the same direction as the telescope.
7. Set lens to desired f-stop and focus at infinity.
8. Attach locking cable release.
9. Orient telescope so that area or object to be photographed is in the camera's viewfinder. NOTE: Some objects are so faint that they cannot be seen. In this case, use telescope setting circles and/or compare the view against a star chart to be certain of proper orientation.
10. Set camera shutter speed to B (bulb).
11. Turn on motor drive.
12. Check camera lens for condensation and remove if necessary.
13. Begin exposure (have lens cap handy) by *gently* depressing and locking cable release. (NOTE: If telescope drive is manual, see Chapter 5 for information to keep telescope tracking.)
14. Time exposure.
15. Unlock cable release to end exposure.
16. Record all pertinent data.

If the telescope's drive mechanism is not accurate and/or suffers from very large periodic errors, and if a very long focal length lens is used, it may be necessary to guide the telescope during the exposure in order to avoid star trailing. If the above instructions have been carefully followed (paying particular attention to polar alignment) and the star images are unsatisfactory, see Chapter 5.

Deep-Sky Guided Photography

If a telescope's drive system is not *absolutely* accurate and/or if *exact* polar alignment cannot be achieved, it will be necessary to make corrections in right ascension and declination during the course of the exposure. (This cannot be done for photographs of the sun, moon, and planets, because the exposure times are too short.) Corrections in right ascension overcome errors in the telescope's drive, and corrections in declination overcome errors in polar alignment. To a lesser degree, both also correct for atmospheric refraction.

GUIDING EYEPIECES

One essential component for guiding (making corrections) is an eyepiece with a crosshair reticle (Figure 5.1). Virtually all telescope companies offer them. Most have a variable intensity light source that illuminates the crosshairs and makes

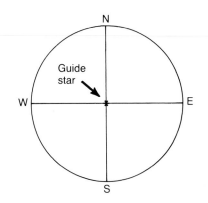

5.1 Although the crosshair patterns vary greatly, they all serve to assist the astrophotographer in keeping a guide star in a fixed position during the course of an exposure. The compass points positions will be determined by the optical system of the telescope; some will reverse east and west and some will reverse north and south. In this guiding eyepiece pattern, compass points are shown for reference only.

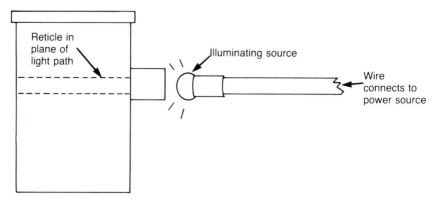

Reticle in plane of light path

Illuminating source

Wire connects to power source

5.2 *Illuminated reticle guiding eyepieces use incandescent bulbs or power-saving LEDs as the light source. Most are equipped with a means to alter the brightness. Some have a battery pack for* *power and some have a wire that plugs into a drive corrector. Others have a small battery built into the eyepiece which eliminates a dangling wire.*

them visible against the dark night sky (Figure 5.2). This eyepiece is focused on the brightest star within the field being photographed, with the brightness of the crosshairs set to a level where both the crosshairs and the star can be seen clearly. A very bright star requires high illumination, a dim star less. NOTE: When photographing a comet, which moves at a rate different from the stars, the head of the comet is guided, not a star.

GUIDING POWER

The focal lengths of guiding eyepieces vary, which makes the *power* of guiding systems vary also. Generally speaking, the focal length of the guiding system should be at least twice that of the photographic lens or telescope. For instance, if a 500mm lens is used to take a picture, we can reckon the lens power at about 10. That is, its focal length is 10 times that of a normal 50mm lens. (Although 50mm does not actually correspond to 1 ×, it is a practical formula for this purpose.) Therefore the guiding power should be at least 20×.

All astronomical telescopes will provide much more than 20× with any of these eyepieces and are suitable for virtually all piggyback photos. The higher the power of the guide system in relation to the photographic lens, the more satisfactory the picture. Sharper star images should result because of more critical guiding. The highest power that shows the guide star bright enough for guiding should be used. In some cases, when taking deep-sky photographs *through* a telescope, it may be necessary to use a Barlow lens in conjunction with the guiding eyepiece to increase power because of the very long focal lengths of most telescopes.

DRIVE CORRECTORS

Another essential for *guided* deep-sky photography is a means to make corrections in right ascension. Because all telescopes have periodic errors in their drive systems that cause images to wander east and west to a greater or lesser degree, satisfactory photos cannot always be attained. In some piggyback, and in all deep-sky photography *through* a telescope, a means to correct these errors is required. Although some telescope clock drives can be adjusted mechanically during exposure, most require an electronic device that alters the speed of the drive motor. These devices are available from most telescope manufacturers, and are usually called drive correctors.

Drive correctors (Figure 5.3) are used in combination with guiding eyepieces. Some can be operated from standard household current, some from a D.C. source such as an automobile battery, and some from both. All are equipped with buttons or levers that increase or decrease the telescope's motor speed at the photographer's will.

DECLINATION CORRECTIONS

The last essential requirement is a means to make corrections in declination. Polar misalignment to a greater or lesser degree will cause the image to drift north or south in declination rapidly or slowly. Most telescopes have a manual means to make corrections in this direction (Figures 5.4 and 5.5), and some have an electric motor (usually an option) controlled by a drive corrector. Declination corrections (unlike right ascension) should not have to be made very often if polar alignment is close to accurate. Should frequent declination correction in one direction be necessary, the photo will probably record field rotation—stars further from the guide star will look like increasingly longer arcs. NOTE: Unless a very large telescope is used where the manual declination control is awkward to adjust, an electric

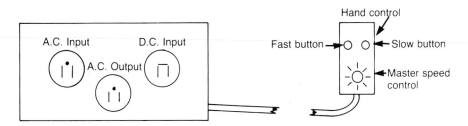

5.3 *Drive correctors change the speed of telescope drive motors to enable the astrophotographer to keep a guide star centered in right ascension. Variations and* *extra features abound. The wise buyer will shop the market to find the one best suited for the needs at hand.*

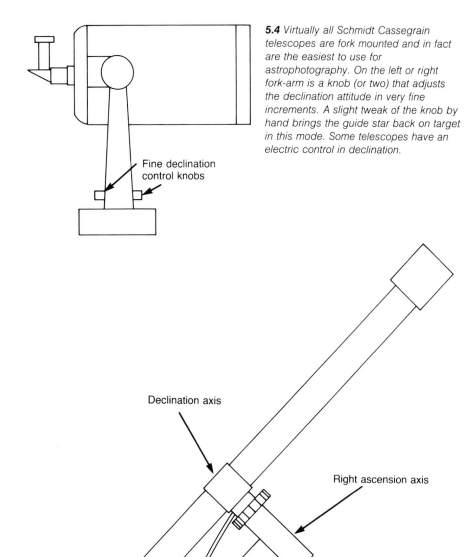

5.4 *Virtually all Schmidt Cassegrain telescopes are fork mounted and in fact are the easiest to use for astrophotography. On the left or right fork-arm is a knob (or two) that adjusts the declination attitude in very fine increments. A slight tweak of the knob by hand brings the guide star back on target in this mode. Some telescopes have an electric control in declination.*

Fine declination control knobs

Declination axis

Right ascension axis

Declination control knob

5.5 *Most German equatorial mounts for refracting and reflecting telescopes have a declination control that utilizes a flexible* cable. *Caution must be used in order to avoid vibration induced by the cable's tendency to flop around when let go.*

control is not only unnecessary, it can be a detriment because of its tendency to overcorrect. Very fine declination adjustments are best accomplished by hand.

To guide a telescope for deep-sky photography, proceed as follows:

1. Load camera with ISO 400 or 1000 film.
2. Take normal photograph in daylight.
3. If piggyback, select proper lens to cover field.
4. Accurately polar align telescope.
5. Mount camera on telescope.
6. Attach locking cable release.
7. Set camera's shutter speed to B (bulb).
8. Turn on motor drive.
9. Locate area to be photographed in camera's viewfinder and focus.
10. Select guide star and center in guiding eyepiece.
11. Adjust illumination to proper brightness.
12. Rotate eyepiece in holder so that the star image will travel along the north/south (declination) line and east/west (right ascension) line when the telescope is moved manually. This will aid in determining the directions in which corrections are needed during the exposure.
13. With guide star centered on crosshairs, begin exposure by depressing and locking cable release. (Have lens cap handy to block unwanted light.)
14. Time exposure.
15. During exposure, note the position of the guide star in relation to the crosshairs of the guiding eyepiece. If it moves to the east or west, speed up or slow down the motor of the telescope with the drive corrector and keep the star centered as accurately as possible. If the telescope's right ascension control is manual, even more diligence is needed. *Never* look away from the eyepiece. While monitoring right ascension, observe any drift in declination and make corrections accordingly. If the exposure begins east of the meridian and ends west of it, it is likely that corrections in declination will reverse. If beginning adjustments were in a southerly direction, they will probably shift to northerly. [NOTE: This aspect of guiding requires constant attention. During long exposures (some may exceed one hour) boredom can cause carelessness which will show in the final result. The author maintains his sanity by listening to music via headphones from a portable tape player and selects the composition according to the length of the exposure. For instance, if a one-hour exposure is planned, he listens to Beethoven's "Ninth" or Mahler's "Titan."]
16. Unlock cable release to end exposure.
17. Record all pertinent data.

Focusing Camera and Telescope

Celestial photography through camera *lenses* presents no focus problem because all the lenses are set to infinity (except some mirror lenses which go beyond and must be visually focused). Telescopes, however, do not have a fixed point of infinity focus. Therefore, focus is determined visually by examining the image on the camera's viewscreen. (Figure 6.1).

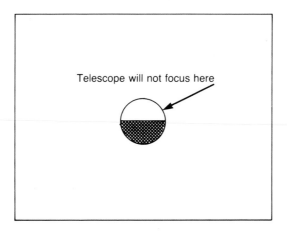

Telescope will not focus here

6.1 *The central focusing spots found in one form or another on normal focusing screens are useless for telescopes and very long lenses. Learn to focus images outside the central area.*

6.2 Some cameras can be fitted with additional viewscreens by the consumer or a service facility. Some astrophotographers have their cameras fitted with a clear center screen. The central clear spot is used for critical telescopic focusing and the surrounding area for normal lens focusing.

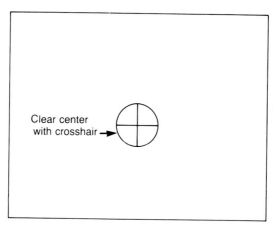

Clear center
with crosshair →

6.3 With the caveat noted in the text, a special aerial image clear focusing screen is the very best for sky photography. If your camera is designed for consumer changeable screens, and if the manufacturer makes a clear screen for your camera, buy one. It is useful for all forms of astrophotography and once tried will be employed constantly. It is not useful for general photography with standard focal length lenses.

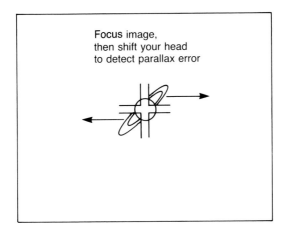

Focus image,
then shift your head
to detect parallax error

6.4 *Because the eye tends to justify an out-of-focus image on a clear screen, care must be taken to avoid parallax error. A little practice will make the procedure second nature. Many clear screens have a finely divided center crosshair to assist in avoiding parallax error.*

CLEAR VIEWSCREENS AND PARALLAX CORRECTION

The moon, sun, and major planets are bright, but many deep-sky objects are so dim that it is necessary to locate them in the camera's viewfinder by using the telescope's setting circles and comparing the view against a star chart. If your camera can be fitted with a clear or aerial image screen (Figures 6.2 and 6.3), many more stars and some nebulae will be apparent. A clear screen aids greatly in locating nebulae, but care must be taken to avoid parallax error, because the eye tends to correct an out-of-focus image. A clear screen is used in combination with a camera's diopter correcting (focusing) eyepiece. The "trick" is to focus the eyepiece on a pattern on the screen, and then focus the telescope until the image appears sharp. The next step is to move one's head slightly from side to side and observe any displacement of the telescopic image with respect to the pattern on the screen. If motion is detected, refocus the telescope (not the camera's eyepiece) until the image is stable (Figure 6.4).

A clear screen is just fine for "extended" objects such as planets and the moon, but stars are visual pinpoints and require another step. First, focus a bright star on a nonclear screen, and without changing the telescope's focus, change to the clear screen to aid in locating the nebulae to be photographed. Refocusing the *camera's* eyepiece to accommodate vision is all right, *but don't refocus the telescope.*

NOTE: Consider the purchase of a used camera body that can accomodate both types of screens (Figure 6.5). A clear screen is an asset and the cost of a camera body over a lifetime amortizes easily.

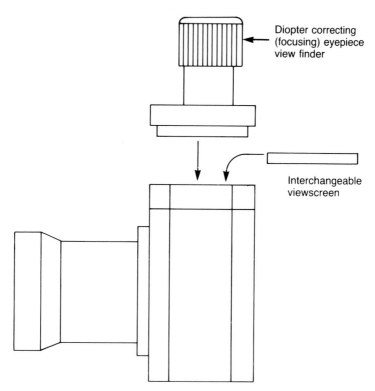

Diopter correcting (focusing) eyepiece view finder

Interchangeable viewscreen

6.5 *Many top-of-the-line cameras have interchangeable viewfinders. These convert standard straight-through finders to right-angle finders that are very helpful* *for astrophotography. All such cameras have easily interchangeable viewscreens also. Consider buying a used camera body with these features.*

chapter 7

Deep-Sky Photography through a Telescope

Unlike some piggyback deep-sky photography, long exposures of galaxies and nebulae (Figure 7.1) *through* telescopes require guiding. The long focal lengths of scopes do not allow sharp stellar images to record without guiding unless the instrument has a perfect right ascension drive, absolute polar alignment and no atmospheric refraction exists. An impossible set of conditions!

When guiding a piggyback photo, a guiding eyepiece is inserted into the telescope's ocular holder. Where is the guiding eyepiece placed when the photo is to be taken through the telescope? After all, if the guide ocular is placed where a viewing ocular is normally located, there is no place to attach a camera body. There are two ways to overcome this problem.

GUIDE TELESCOPES

The classical guiding system employs a second telescope. One scope is the photographic lens, and the other is the guiding system utilizing a guiding eyepiece. The telescopes are connected side by side so that both are aimed at the same part of the sky (Figure 7.2). Once the object to be photographed is centered in

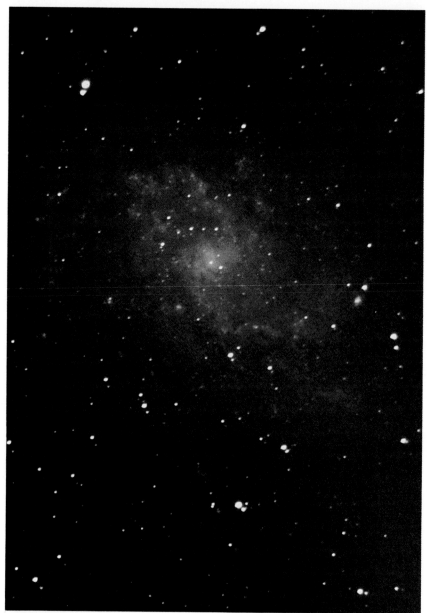

7.1 *Spiral Galaxy in Triangulum (M-33). 75 minutes, 2000mm f/10, 8-inch aperture Schmidt Cassegrain telescope, ISO 400 cooled Ektachrome film.* NOTE: *All of the photographs in this chapter, with the exception of Figure 7.6, were taken with a cold camera. All were taken before the introduction of ISO 1000 films. As explained in the text, the author believes that, for the beginner at least, cold cameras and other methods of treating films are no longer necessary. Compare Figure 7.5, a 45-minute ISO 400 cold camera photo, to Figure 7.6, a 10-minute ISO 1000 noncold camera photo taken by* Sky & Telescope's *associate editor Dennis di Cicco. Newer and better films will always be brought to market. Experiment with the new ones.*

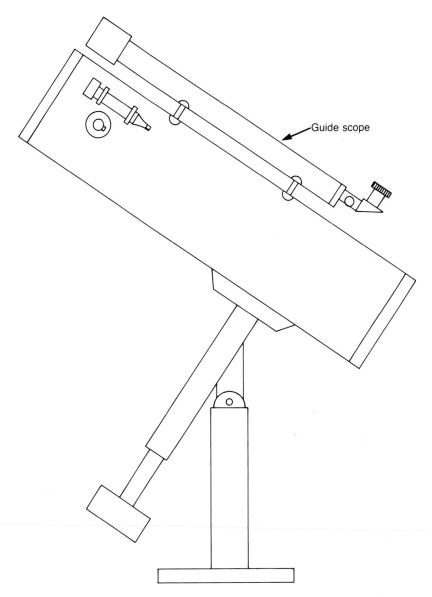

Guide scope

Fig 7.2 *A refractor guide scope mounted on a Newtonian reflector. Be certain that guide scope is firmly mounted. If it shifts position ever so slightly during an exposure, the results will be poor. If a catadioptric (mirror lens) scope is used,* beware of possible image shift due to a loose fitting mirror. This is likely to happen if a photograph is started east of the meridian and concludes west of the meridian.

the viewscreen of the camera, the guide scope is adjusted until a suitable guide star is centered on the reticle of the guiding eyepiece. The major drawbacks to this method are the expense of another telescope tube assembly (usually a refractor) and the additional weight and bulk.

OFF-AXIS GUIDERS

A second, more recent guiding system uses a special prism assembly often called an off-axis guider (Figure 7.3). It connects to the telescope's mechanism where an eyepiece or star diagonal prism is normally placed. In this device, a very small prism deflects the light from the guide star which is located outside the circle of light reaching the camera's rectangular film plane, and directs the star's light to

7.3 *An off-axis guider mounted on a Schmidt Cassegrain telescope.* NOTE: *Both guide scopes and off-axis guiders are* *obtainable for all forms of telescopes. The advanced astrophotographer will probably use both as requirements dictate.*

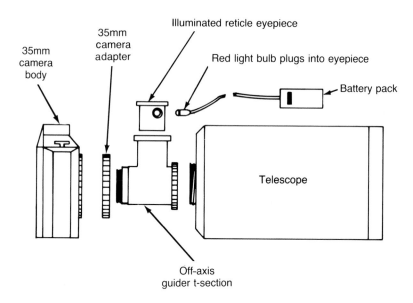

the guiding eyepiece. This system is the most commonly used because it is relatively inexpensive, compact, and lightweight. Once the object to be photographed is located in the camera's viewfinder, the telescope is shifted slightly in varying directions and/or the guiding assembly is rotated until a suitable guide star is centered on the crosshairs of the guiding eyepiece. The major drawback of this system is the very restricted area in which to find a proper guide star. If the scope is shifted too much in locating the star, the object to be photographed may no longer be in the camera's viewfinder or it may be partially obscured. Sometimes one has to settle for a very dim star that is difficult to track. With a little practice, the photographer learns to see stars dimmer than thought possible. Even so, a suitable star cannot always be found.

RECIPROCITY FAILURE AND EXPOSURE TIMES

Exposure times are best estimated by examining photos taken by others and extrapolating data. For instance, if a photo of the Great Nebula in Orion taken at f/10 using 400 speed film required 45 minutes to expose (Figures 7.4 and 7.5), an f/5 telescope would need about 12 minutes because f/5 is four times faster than f/10. If 1000 speed film at f/10 were to be used, the exposure should be about two and a half times faster—18 minutes. However, because most films suffer from reciprocity failure (loss of speed and shifting of color balance) during long exposures, only trial and error will determine the best exposure time for a given object. See Figure 7.6, where only 10 minutes were required. Virtually all deep-sky objects should record on 1000 speed film within a range of 10 to 45 minutes with a relatively slow f/10 telescope. It is important to know that it is the f/ratio and *not* the aperture of the instrument that determines photographic times for nebulae.

Many telescope suppliers offer an optical component called a *focal reducer* or *telecompressor* which is mounted between the scope and the camera body. Most will appear to cut the focal length of a telescope in half and increase the photographic speed by a factor of 4. Most will cause some vignetting on 35mm-format film and, of course, reduce image scale to one half of what the telescope produces without it. However, ISO 1000 speed films have so drastically cut exposure times over older films that focal reducers are falling into disuse. If an object is too large to fit on 35mm film, a focal reducer can sometimes be a help. For instance the Andromeda Galaxy is too large when using a focal length of 2000mm (see Figure 7.7). A focal reducer would reduce the photographic scale and enable the entire structure to fit.

Another means to help overcome reciprocity failure is a *cold camera*. This is a device in which film is placed into a chamber and is chilled with dry ice to its temperature. At such low temperatures, film overcomes much reciprocity failure and produces fine deep-sky photos. However, these cameras are quite expensive and difficult to use. Most require the film to be cut into small pieces and to be developed at home or by a custom lab.

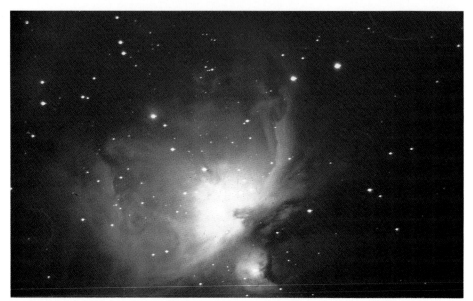

7.4 *Orion (M-42). 45 minutes, 2000mm f/10, 8-inch aperture Schmidt Cassegrain telescope, ISO 400 cooled Ektachrome film. Note the elongation of the stars. During the exposure the author* *inadvertently kicked the telescope's tripod. Even though the scope was replaced on target with the guiding eyepiece, the whole system was misaligned. Don't kick the system!*

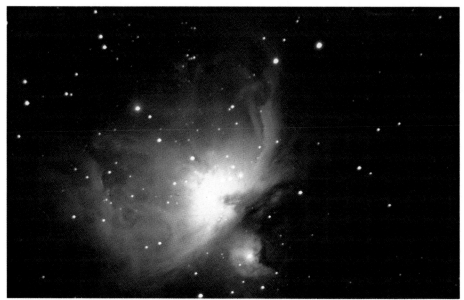

7.5 *Orion repeated. After completing the "kicked" exposure, the author repeated the photo with the same exposure time,* *etc., but refrained from kicking. The star images show his restraint.*

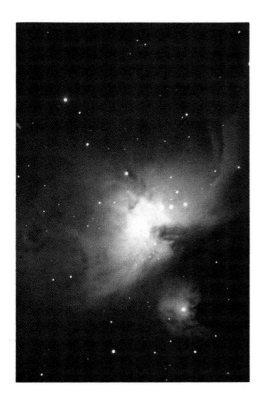

7.6 *Orion (M-42). 10 minutes, 2750mm f/10,11-inch aperture Schmidt Cassegrain telescope, ISO 1000 3M slide film. Compare this 10-minute photo to Figure 7.5, a 45-minute photo of Orion, and you will see the great advance in film speed. The new family of ultra-fast films has made astrophotography a lot easier than in recent times. Illustration used with permission of Dennis di Cicco.*

7.7 *Andromeda (M-31). 60 minutes, 2000mm f/10, 8-inch aperture Schmidt Cassegrain telescope, ISO 400 cooled Ektachrome. Too large to fit into a 35mm film format at 2000mm, about two-thirds of our sister galaxy is shown here. Note the bright companion galaxy centered above Andromeda.*

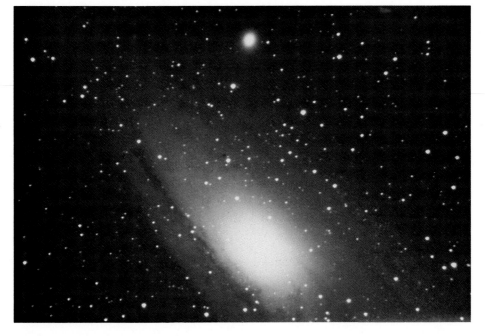

Yet another method to overcome reciprocity failure is by treating unexposed film with certain gases. This produces much the same effect as a cold camera but is far simpler to use. Hypersensitized film can be purchased and a kit for treating your own film is also available. (See advertisements in the astronomy journals for details.) These films can be processed normally after exposure.

Once again, the new superfast films will probably make both of the above methods obsolete except when really special requirements must be met. In any case, these methods are not for the beginner

To photograph, proceed as follows:

1. Load camera with ISO 1000 speed film.
2. Take normal photo in daylight.
3. Accurately polar align telescope.
4. Attach guiding system.
5. Mount camera.
6. Attach locking cable release.
7. Set camera exposure setting to B (bulb).
8. Adjust balance of telescope so that it is slightly heavier at the optical entrance or exit. This will tend to keep the gears of the drive mechanism in contact. Keep in mind that if the photo is timed so that it begins east of the local meridian and ends west of the meridian, the instrument will probably shift slightly to take up gear slack. This can ruin the picture because bright star images, which record much faster than deep-sky nebulae, will probably record slightly elongated before one recenters the guide star against the eyepiece crosshairs. If the gear slack is not too great and the photographer is diligent in making a very rapid correction, the photo should be fine. To avoid this problem, time the photo so that it begins and ends on the east or west side of the meridian. Again, the finest photos are obtained when the object is nearest the meridian because the atmosphere is least dense. Figures 7.8 and 7.9 illustrate how to compensate when the object is not in the best position.
9. Turn on motor drive/drive corrector.
10. Illuminate guiding ocular (if it has a light source).
11. Locate field to be photographed in viewfinder of camera and focus.
12. Adjust telescope so that a guide star is visible in and centered on the crosshairs of the guiding eyepiece.
13. Orient eyepiece so that guide star "travel" is north/south and east/west.
14. With guide star centered on crosshairs, begin exposure by locking the cable release. (Have lens cap handy, as explained in Chapter 4.)
15. Time exposure.
16. During exposure monitor the guide star and make corrections as needed. (Figures 7.4, 7.10, and 7.11 illustrate some of the many things that can go

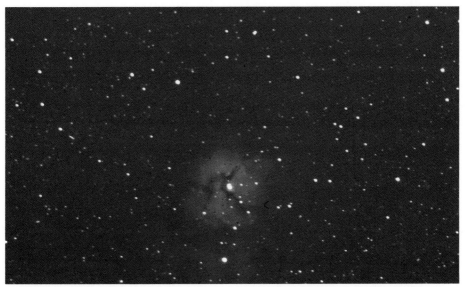

7.8 *Trifid (M-20). 60 minutes, 2000mm f/10, 8-inch aperture Schmidt Cassegrain telescope, ISO 400 cooled Ektachrome. Although the photo was taken about 50 miles north of a major city, sky glow from lights and air pollution (the Trifid was low in the sky) caused a washed-out effect. Using a simple lens/slide duplicator and ISO 64 Ektachrome film, the duplicate, as shown, is a vast improvement on the original. Every form of photography, including astronomical, has its own tricks.*

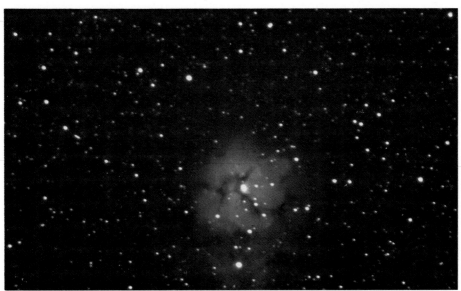

7.9 *Trifid duplicated as described. Note the improved contrast and color enhancement. See Figure 4.14 for some bad news about duplicating from a duplicate slide.*

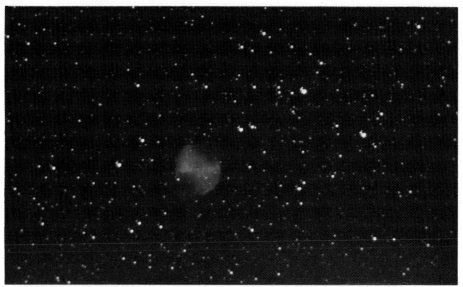

7.10 *Dumbell (M-27). 45 minutes, 2000mm f/10, 8-inch aperture Schmidt Cassegrain telescope, ISO 400 cooled Ektachrome. Note the poor star images. This was shot under windy conditions which made it* impossible to keep the guide star centered. Similar results occur as a result of poor guiding techniques. In astrophotography, wind is an enemy!

7.11 *Ring (M-57). 20 minutes, 2000mm f/10, 8-inch aperture Schmidt Cassegrain telescope, ISO 400 cooled Ektachrome.* Here, the wind was not the problem; the guiding was not the best.

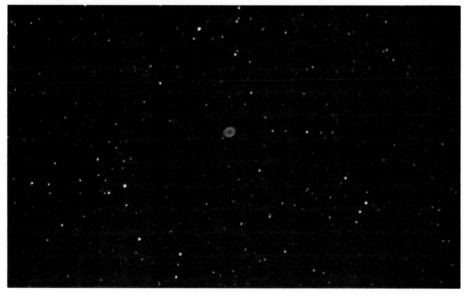

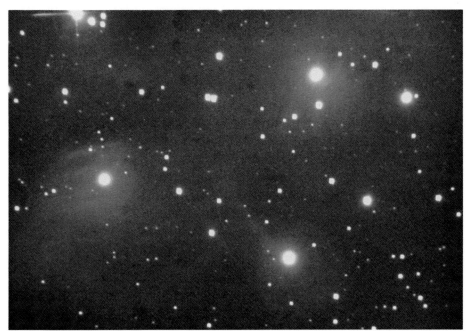

7.12 *Pleiades (M-45). 60 minutes, 2000mm f/10, 8-inch aperture Schmidt Cassegrain telescope, ISO 400 cooled Ektachrome. Streak of light in upper left is due to* *reflection of bright star near edge of field, a common "defect" in telescopic photography.*

wrong, but the other photos show that things sometimes *do* go right.)

17. Unlock cable release to end exposure.

18. Record all pertinent data.

High-Power Photography with a Telescope

All telescopes are capable of photographing the sun, moon, and planets by simply attaching a camera body to the telescope's focus. (See Chapter 2 for safety procedures in photographing the sun.) The sun and moon subtend angles large enough for lovely pictures to be taken this way, but the planets subtend such small angles that almost no detail will show up in the photos. In order to photograph impressive details of some of the planets, craters on the moon, and closeups of sunspots, it is necessary to increase the effective focal lengths of telescopes, using *eyepiece projection*.

EYEPIECE PROJECTION

An eyepiece is inserted between the telescope and the camera body so that the image is projected to the film plane through the ocular (Figure 8.1). The focal length of the ocular and its distance from the film determines the effective focal length of the overall system (Figure 8.2). Sometimes the focal lengths and consequent f/ratios are staggering! See Figure 8.3, the photo of Mars shot at 33,000mm, f/165 through an 8-inch aperture telescope when the planet was about as close to earth as it ever gets (36 million miles). See also Figures 8.4 and 8.5, showing Jupiter at effective focal lengths of 2000 and 25,000mm.

NOTE: Although the sun, moon, and planets move across the sky at different rates than stars (and each other), the differences are not great enough to make

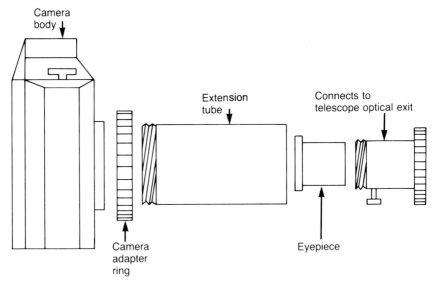

8.1 *Typical eyepiece projection assembly.*

8.2 *Determining effective focal lengths and f/ratios.*
Formula: FL × CL *divided by* D × EL
Example: FL = 1200mm × CL = 50mm
= 60,000

D = 100mm × EL = 30mm = 3000
60,000 ÷ 3000 = 20
Result: effective focal ratio f/20
effective focal length, 2000mm
(20 × 100mm objective diameter)

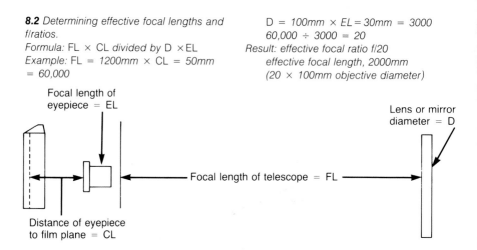

8.3 Mars. 3 seconds. 33,000mm effective focal length, 8-inch aperture Schmidt Cassegrain telescope, f/165, ISO 160 Ektachrome. Shot in smoggy New York City when the planet was only some 36,000,000 miles away. The author was not pleased with this photo until he compared it to the results obtained by professionals at the same time. Mars is very amorphous visually and photographically.

8.4 Jupiter and its four brightest moons. 15 seconds, 2000mm f/10, 8-inch aperture Schmidt Cassegrain telescope, ISO 160 Ektachrome. In order to record its moons, Jupiter was deliberately overexposed, causing the planet to appear larger than it should at 2000mm. Given the small image scale, no meaningful detail would show up at 2000mm. Eyepiece projection photography is needed to record detail.

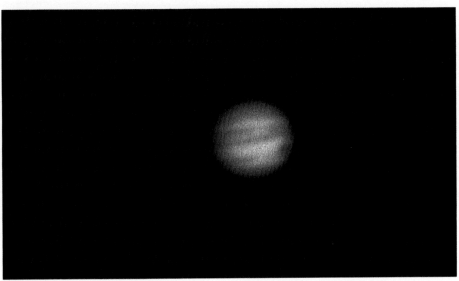

8.5 *Jupiter. 5 seconds, 25,000mm effective focal length, 8-inch aperture Schmidt Cassegrain telescope, f/125, ISO 160 Ektachrome. The red spot is clearly seen in this New York City shot. Photographed during high smog (see text), this was the only really satisfactory photo out of 36.*

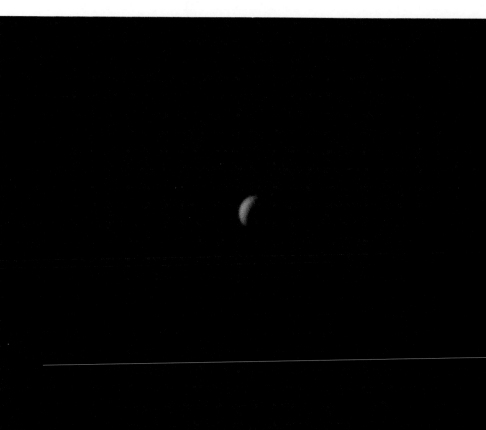

8.6 *Venus. 0.5 second, 25,000mm effective focal length, 8-inch aperture Schmidt Cassegrain telescope, f/125, ISO 64 Kodachrome X film. This film "leaned" toward red coloring. The red color was further enhanced by the position of the planet—low in the western sky. 100 miles of Earth's atmosphere do not help. About all the amateur can hope to see and photograph are the phases of this planet.*

altering of the drive system necessary. The standard drive speed is perfectly fine for this form of photography. Figure 8.6 suggests a series of photos of phases of Venus.

Even at 33,000mm, the image of Mars on film is only about 4mm in diameter. If the full moon (or sun) were photographed at the same effective focal length, its diameter would be about 11.5 *inches*. (However, see Figures 8.7, 8.8, and 8.9 for closeups of the moon.) To photograph Mars at the same image scale, a focal length of about 2,400,000mm (f/12,000) would be required and the image would be too dim to see. Focusing with ratios higher than f/165 is almost beyond practical limits—especially for the beginner.

This form of celestial photography is the most difficult! Figure 8.10 illustrates how trying it can be. Although deep-sky photos are reckoned in times of up to

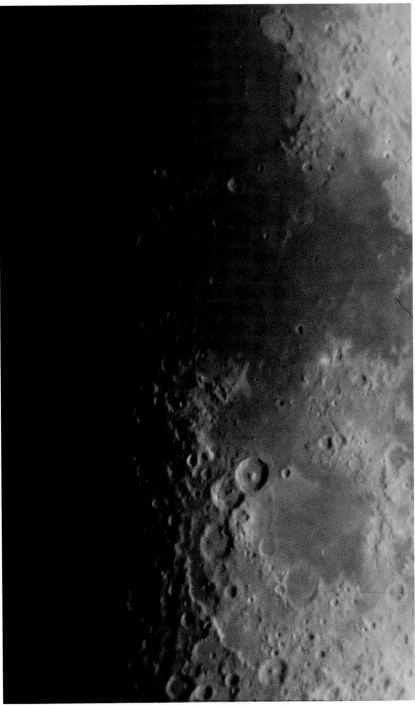

8.7 *Moon. 0.5 second, 7100mm effective focal length, 4-inch aperture Schmidt Cassegrain telescope, f/71, ISO 160* *Ektachrome. Although the moon is black and white, color can add spice.*

8.8 *Moon. Crater Plato and Alpine Valley. 3 seconds, 25,000mm effective focal length, 8-inch aperture Schmidt* *Cassegrain telescope, f/125, ISO 160 Ektachrome.*

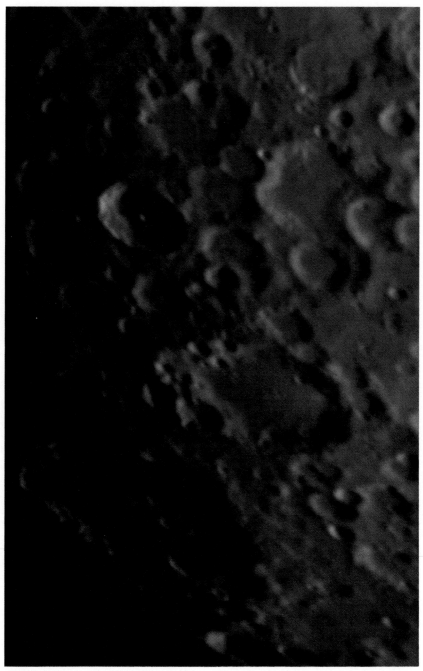

8.9 *Moon. Clavius region. 2 seconds, 25,000mm effective focal length, 8-inch aperture Schmidt Cassegrain telescope, f/ 125, ISO 160 Ektachrome.*

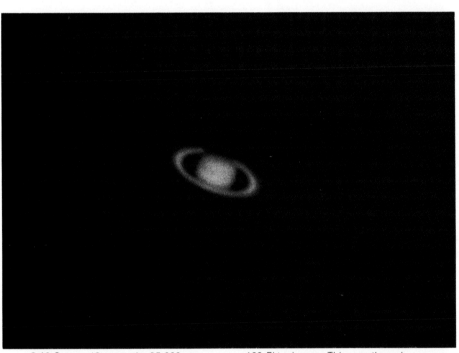

8.10 *Saturn. 13 seconds, 25,000mm effective focal length, 8-inch aperture Schmidt Cassegrain telescope, f/125, ISO 160 Ektachrome. This was the only satisfactory photo out of 72 tries.*

an hour or more, and high-power planetary photos are shot in no more than several seconds, the latter are much more difficult because there is no room for error. Deep-sky photos can be corrected for drive error, slight polar misalignment, and even *light* winds during the exposure. Even moderate atmospheric turbulence is not always a problem. It is precisely these factors that cannot be overcome in high-power telescopic photography. *Mechanical and atmospheric conditions must be perfect!* Some of the factors to be considered follow.

CRITICAL MECHANICAL AND ATMOSPHERIC FACTORS

Light Pollution Obviously light pollution is not a problem when photographing the sun, nor for the moon, Mercury, Venus, Mars, Jupiter, and Saturn. (The more distant planets record as "stars" because of their extreme distances.) Certainly a street light or other bright light source should be far out of the field.

Polar Alignment Because any drift in declination will "smear" the image, polar alignment should be nearly perfect. The higher the f/ratio and the longer the exposure, the more critical accurate polar alignment becomes.

Clock Drive All drives have periodic errors and can be "timed" so that they are predictable. Photos should be taken during periods of stability. Some drives wander in a matter of a few seconds; others take longer. Observe the image in the camera's viewfinder to determine periods of error-free motion.

Wind Absolute calm is needed. If wind of any strength is consistent, forget it! Otherwise, wait for a calm period and hope it remains for the duration of the exposure.

Smog Good! Although atmospheric pollutants cut the light and necessitate longer exposure times, it indicates that an inversion layer exists in the atmosphere and the air is still. Fine planetary photography (and viewing) is possible in metropolitan areas under smog conditions (see Figures 8.3 and 8.5). Of course, the very best planetary photos are taken in areas away from smog—but when an inversion atmosphere is present—because the exposures are shorter.

Humidity Some of the best planetary photography (and viewing) is done under conditons of still air and high humidity. The major problem induced by moisture is condensation forming on the optical surfaces. Unless the condition is severe, moisture can be removed by using an electric hair dryer or other heat source for periods long enough to photograph.

Vibration Even very slight vibration is a problem. Almost all camera shutter mechanisms induce some vibration, but its magnitude is generally so light that it

is seldom a problem. The vibration caused by the flipping up of the reflex mirror just prior to the opening of the shutter lasts longer and can be ruinous in very short exposures. Longer exposures are generally not affected, because no meaningful image is formed so quickly.

Some cameras have a mechanism that permits the mirror to be released without automatically opening the shutter. This permits the photographer to pause and let the mirror vibration dissipate prior to opening the shutter. In activating these mechanisms, care must be taken against moving the scope and causing the highly magnified image to shift. With the mirror released, the image cannot be seen and may be out of the field. Many cameras have a self-timer that releases the mirror as soon as the timer is activated, but does not open the shutter until the end of the timing duration.

If the above conditions cannot be met, the next best approach is the "black hat" method. When the photo is about to be taken, place a piece of cardboard or other material painted with flat (not glossy) black paint in front of the telescope's opening and without touching the instrument, open the camera's shutter with a cable or, preferably, a squeeze-bulb air release, pause to allow all vibration to cease, and *gently* uncover the telescope (don't create a breeze) to begin the exposure. After the exposure time is completed, recover the telescope's opening and close the shutter. This is the most foolproof method of very high-power photography, but is very difficult to use with exposures under 1 second unless the photographer can accurately judge the passing of fractional seconds of time.

Other forms of vibration are equally troublesome. Vehicles passing on a nearby potholed road, trains and subways, sonic booms, and, if the photos are taken from a building roof or balcony, elevators can all create tremors. During the exposure, the photographer and persons around the instrument should remain still.

Focusing Accurate focusing at high power is difficult and the higher the f/ratio, the more difficult it becomes. Each increasing f-stop cuts image brightness in half. Standard focusing screens are not well-suited for planetary photography (nor for most astrophotography). If your camera has interchangeable viewscreens (as discussed in Chapter 6), select one that is clear or has a clear center. This allows "aerial image" focusing just like an eyepiece, and the image will be *much* brighter. If a standard screen must be used, determine the point of focus to the side of the center, as most central focusing configurations are useless with telescopes. Even clear screens render dim images at extreme f/ratios and exact focus is often difficult to determine. It is something of a guessing game.

Power "Seeing" conditions, that is, the state of the atmosphere (still or turbulent), will determine the limit of visual and photograph magnification for a given telescope objective size. A visual rule of thumb is about 60× per inch of diameter under perfect conditions. Since perfection rarely occurs, increase the effective focal length until the image is no longer satisfactory. When it becomes too dim to see, or it wavers with atmospheric turbulence, maximum power has been exceeded.

It is very hard to locate objects at high power. Visually and photographically, a properly aligned finder scope is a great asset. *Gradually* increase power and recenter the image in the viewfinder until the desired effective focal length (image scale) is obtained. Although the formula to determine effective focal lengths and f/ratios is given in Figure 8.2, it is best for the beginner to follow the procedure given above rather than to predetermine what "power" should be used. After gaining experience, the astrophotographer may want to become more selective and try for photos at the highest powers.

Exposure Times When photographing the sun and moon, light meters can sometimes be used as a *starting* point, but they are useless for the planets. Beginners should examine published data and extrapolate. Film speed and f/ratio are the key factors. If a published photo of Mars shows a satisfactory image at f/165 on 160 speed film at 3 seconds, take a series of Mars photos compensating for film speed and f/ratio. If you are using 400 speed film and the same f/ratio, cut the exposure time in half, but take a *series* with slightly varying exposures. Shoot some at 1 second, 1.5 seconds, and 2 seconds. Ideal exposure times will depend upon the altitude of the planet as well as the pollutants in the air. (Always try to photograph objects as close to the meridian as possible.) Very slight exposure time differences (0.5 second) can make sustantial changes in recording subtle detail. Should your f/ratio be one stop faster (f/83), compensate by halving the exposure times. f/Ratios slower than 165 cause such dim images that it becomes virtually impossible to focus accurately.

The best way to determine ideal exposure times for a given object is to take a series at each of the camera's shutter speeds and increase exposures at the B (bulb) setting up to several seconds. Keep a careful record of each exposure and compensate accordingly the next time. However, even if it is determined that a 2-second exposure seems to be the best, it is still a good idea to vary the series slightly. It is essential that a lot of exposures be taken—the requirements are so tough that if only *one* photo out of a full roll of film is really good, you are ahead of the game, as Figures 8.5 and 8.10 show.

Film The beginner should start with the fastest film available because the exposure times will be the shortest. ISO 400 Polaroid Polagraph film, discussed in Chapter 2, is also good for the beginner (Figure 8.11). Fast films may be too grainy to record subtle detail. After gaining experience, the beginner may try slower, finer-grain film. Mastering the technique is most important.

To photograph, proceed as follows:

1. Load camera with ISO 400, or 1000 speed film.
2. Take normal photograph in daylight.
3. Accurately polar align telescope.
4. *Precisely* align finder scope.

8.11 *Moon. 0.25 second, 3700mm effective focal length, 4-inch aperture Schmidt Cassegrain telescope, f/37, ISO 400 Polaroid Polagraph. A wonderful film* for the beginner and in teaching situations because the results are seen about 5 minutes after the last frame is shot. See text for further information.

5. Select lowest power eyepiece and connect the projection system to the telescope.

6. Adjust balance of telescope so that it is slightly heavier at one end. (NOTE: The balance of the popular fork-mounted catadioptric telescopes will always be considerably "tail-heavy" with camera and projection system attached. Because of the construction of these instruments, it is not necessary to offset the great imbalance with counterweights. This is especially so if the object to be photographed is near the meridian. However, if the telescope has a *single* fork arm, it probably will be necessary to achieve balance.)

7. Locate object in center of finder scope.

8. Focus image in camera viewfinder.

9. Carefully change eyepieces until the maximum usable focal length is achieved. Take care not to shift the telescope when changing eyepieces because it will be very difficult to relocate the object at high powers.

10. Recheck focus.

11. Set camera exposure time. If using the B (bulb) setting, use a stopwatch or other device for timing the exposures.

12. Attach cable release, squeeze-bulb air release, or preset self-timer.

13. Begin exposure.

14. Time exposure.

15. End exposure.

16. Record all pertinent data.

NOTES TO READERS AND ASTROPHOTOGRAPHERS

Readers, if as suggested in the "Introduction," you have read this guide cover to cover in one sitting, you now have a pretty good idea of what's required to capture the heavens on film. Much is not difficult—star trails, constellations, our moon, the sun (with the precautions noted) and other celestial panorama are within easy reach. Be prepared to burn up some film. The rewards are legion.

Astrophotographers, you now have experienced the ease of some aspects of this joyful pursuit. Perhaps you are delving into the more demanding areas. Good — persevere. Expect that your first attempts at deep-sky photography through a telescope may not thrill your eyes; certainly your shots of Jupiter or Saturn will look like fuzzy images. Forge ahead, and relish the challenge. Don't skimp on film, and keep your patience level in high gear.